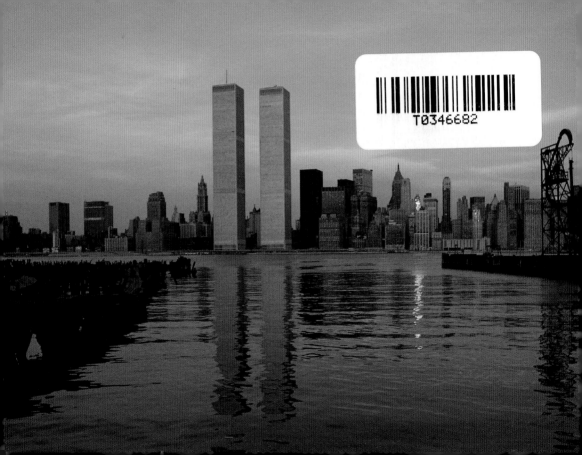

THE VIEW LOOKING EAST

From *The World Trade Center Remembered*, available from Abbeville Press

Copyright © 2003 Abbeville Press, Inc.
Images copyright © Sonja Bullaty and Angelo Lomeo ▪ Printed in Singapore

ABBEVILLE PUBLISHING GROUP
116 West 23rd Street ▪ New York, NY 10011

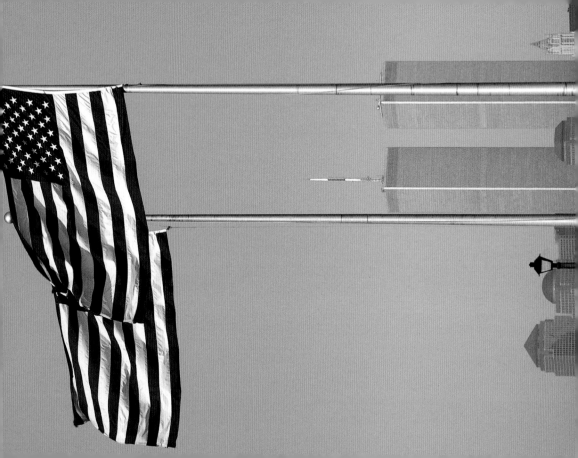

THE VIEW LOOKING EAST

From *The World Trade Center Remembered*, available from Abbeville Press

ABBEVILLE PUBLISHING GROUP
116 West 23rd Street ▪ New York, NY 10011

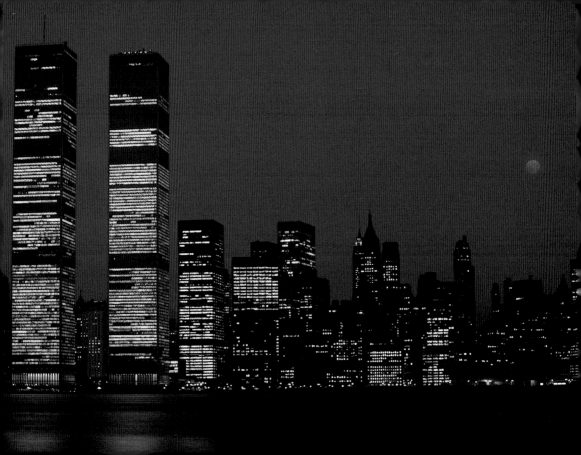

THE VIEW LOOKING EAST

From *The World Trade Center Remembered*, available from Abbeville Press

ABBEVILLE PUBLISHING GROUP
116 West 23rd Street ▪ New York, NY 10011

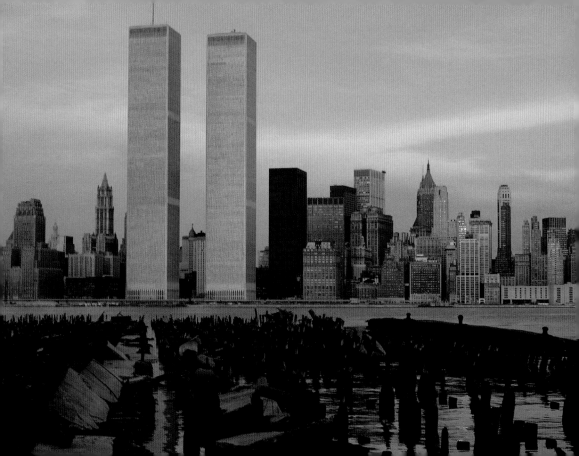

THE VIEW LOOKING EAST

From *The World Trade Center Remembered*, available from Abbeville Press

ABBEVILLE PUBLISHING GROUP
116 West 23rd Street ▪ New York, NY 10011

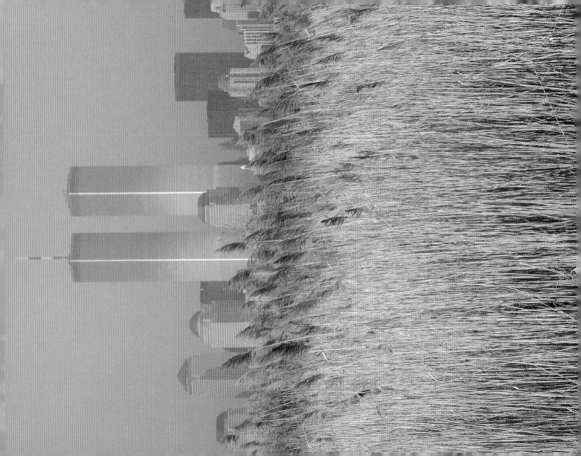

THE VIEW LOOKING EAST

From *The World Trade Center Remembered*, available from Abbeville Press

ABBEVILLE PUBLISHING GROUP
116 West 23rd Street ▪ New York, NY 10011

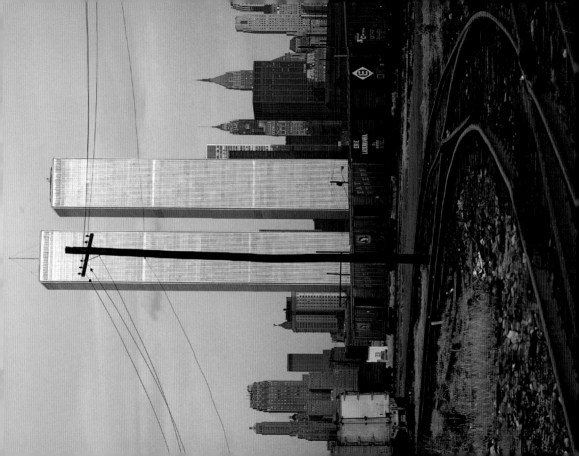

THE VIEW LOOKING EAST

From *The World Trade Center Remembered*, available from Abbeville Press

ABBEVILLE PUBLISHING GROUP
116 West 23rd Street ▪ New York, NY 10011

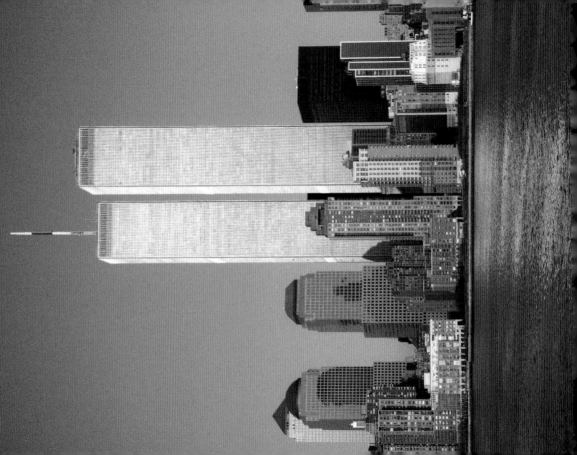

THE VIEW LOOKING EAST

From *The World Trade Center Remembered*, available from Abbeville Press

ABBEVILLE PUBLISHING GROUP
116 West 23rd Street ▪ New York, NY 10011

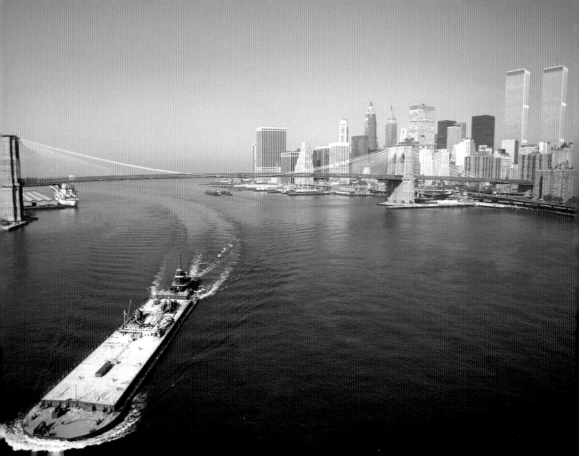

THE VIEW LOOKING SOUTH

From *The World Trade Center Remembered*, available from Abbeville Press

FIRST
CLASS
POSTAGE
REQUIRED

ABBEVILLE PUBLISHING GROUP
116 West 23rd Street ■ New York, NY 10011

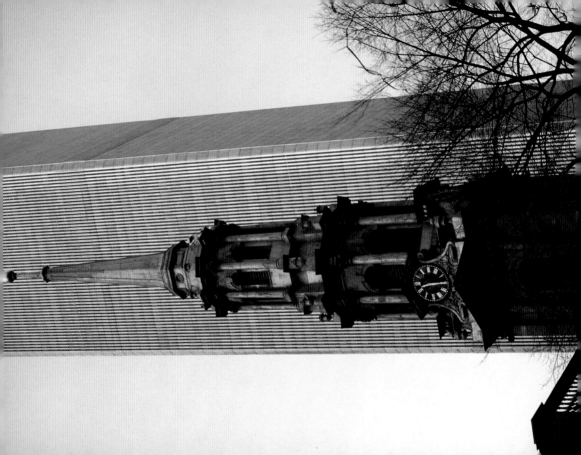

THE VIEW LOOKING SOUTH

From *The World Trade Center Remembered,* available from Abbeville Press

ABBEVILLE PUBLISHING GROUP
116 West 23rd Street ▪ New York, NY 10011

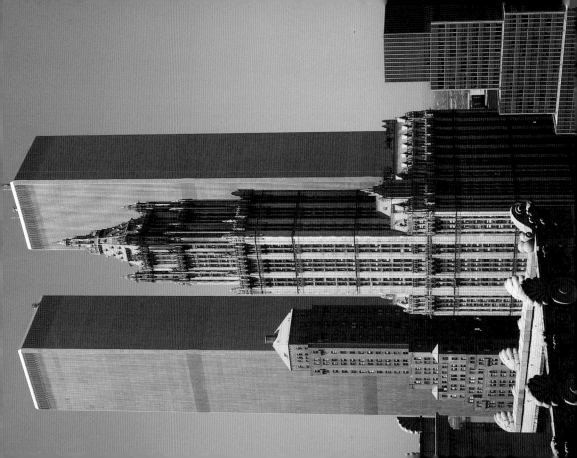

THE VIEW LOOKING SOUTH

From *The World Trade Center Remembered*, available from Abbeville Press

ABBEVILLE PUBLISHING GROUP
116 West 23rd Street ▪ New York, NY 10011

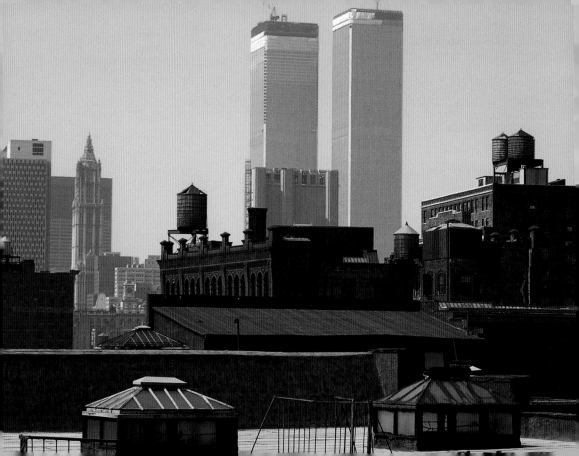

THE VIEW LOOKING SOUTH

From *The World Trade Center Remembered*, available from Abbeville Press

ABBEVILLE PUBLISHING GROUP
116 West 23rd Street ▪ New York, NY 10011

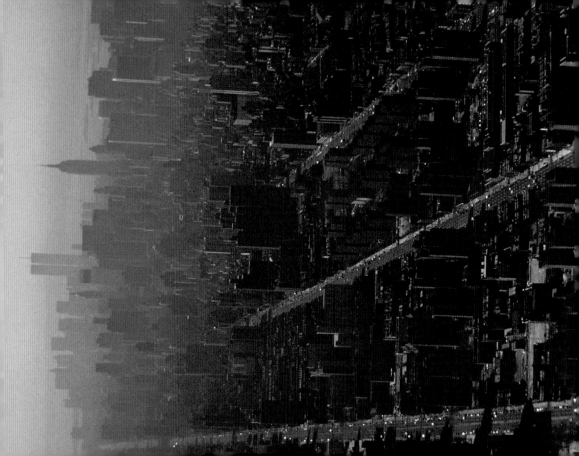

THE VIEW LOOKING SOUTH

From *The World Trade Center Remembered*, available from Abbeville Press

ABBEVILLE PUBLISHING GROUP
116 West 23rd Street ▪ New York, NY 10011

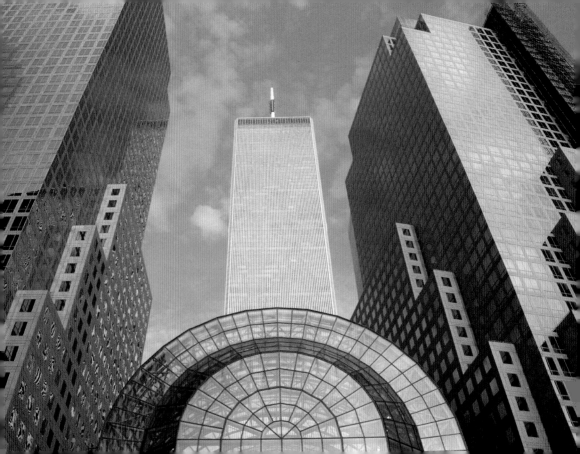

THE PLAZA

From *The World Trade Center Remembered*, available from Abbeville Press

ABBEVILLE PUBLISHING GROUP
116 West 23rd Street ▪ New York, NY 10011

THE PLAZA

From *The World Trade Center Remembered*, available from Abbeville Press

ABBEVILLE PUBLISHING GROUP
116 West 23rd Street • New York, NY 10011

THE PLAZA

From *The World Trade Center Remembered*, available from Abbeville Press

ABBEVILLE PUBLISHING GROUP
116 West 23rd Street ▪ New York, NY 10011

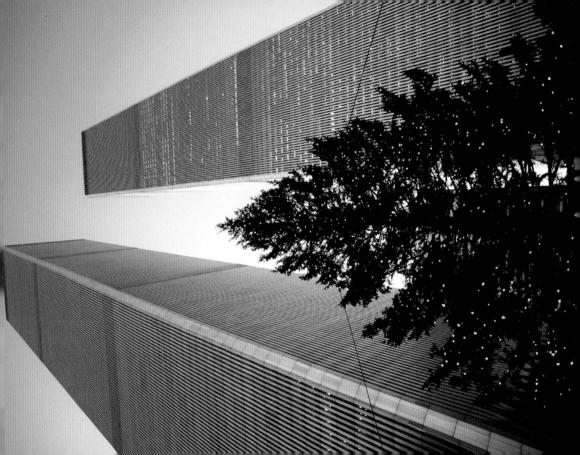

THE PLAZA

From *The World Trade Center Remembered*, available from Abbeville Press

ABBEVILLE PUBLISHING GROUP
116 West 23rd Street ▪ New York, NY 10011

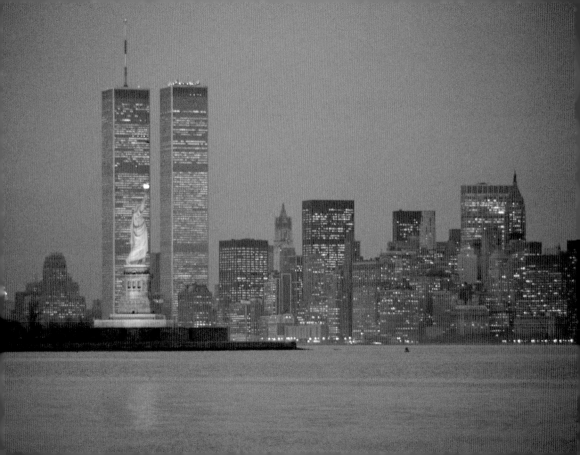

THE VIEW LOOKING NORTH

From *The World Trade Center Remembered*, available from Abbeville Press

ABBEVILLE PUBLISHING GROUP
116 West 23rd Street ▪ New York, NY 10011

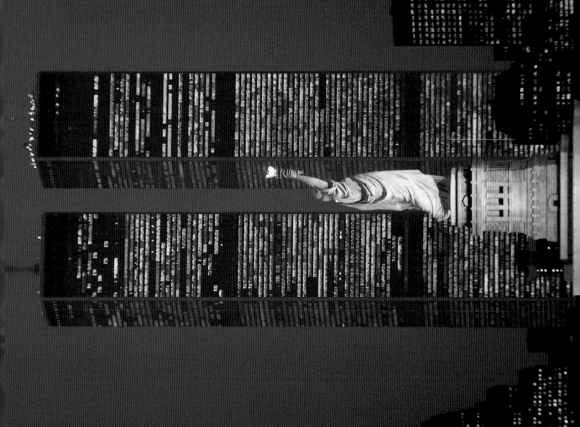

THE VIEW LOOKING NORTH

From *The World Trade Center Remembered*, available from Abbeville Press

ABBEVILLE PUBLISHING GROUP
116 West 23rd Street ▪ New York, NY 10011

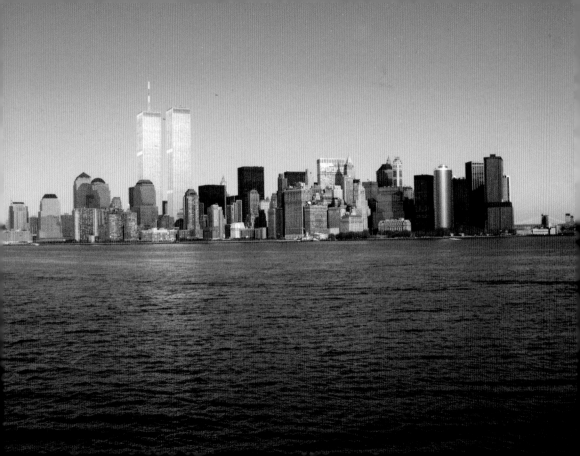

THE VIEW LOOKING NORTH

From *The World Trade Center Remembered*, available from Abbeville Press

Copyright © 2003 Abbeville Press, Inc.
Images copyright © Sonja Bullaty and Angelo Lomeo ■ Printed in Singapore

ABBEVILLE PUBLISHING GROUP
116 West 23rd Street ■ New York, NY 10011

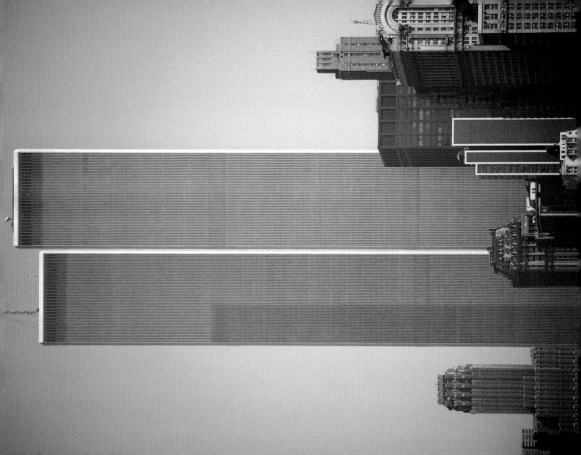

THE VIEW LOOKING NORTH

From *The World Trade Center Remembered*, available from Abbeville Press

ABBEVILLE PUBLISHING GROUP
116 West 23rd Street ▪ New York, NY 10011

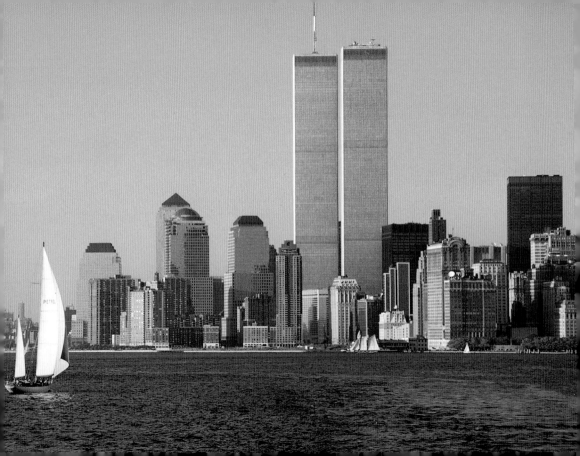

THE VIEW LOOKING NORTH

From *The World Trade Center Remembered*, available from Abbeville Press

ABBEVILLE PUBLISHING GROUP
116 West 23rd Street ▪ New York, NY 10011

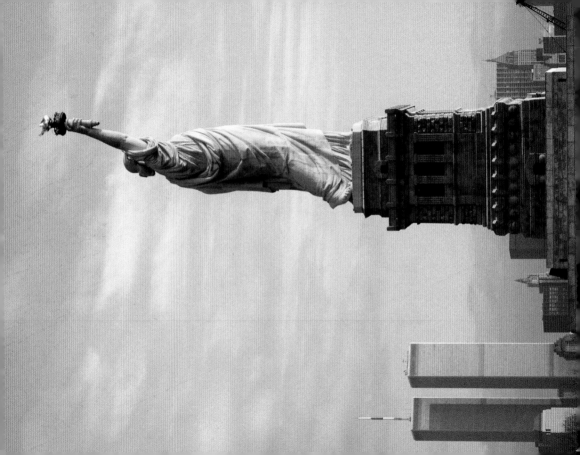

THE VIEW LOOKING NORTH

From *The World Trade Center Remembered*, available from Abbeville Press

ABBEVILLE PUBLISHING GROUP
116 West 23rd Street ▪ New York, NY 10011

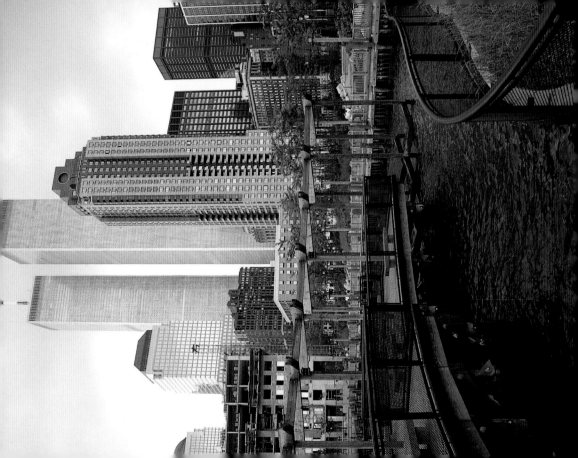

THE VIEW LOOKING NORTH

From *The World Trade Center Remembered*, available from Abbeville Press

ABBEVILLE PUBLISHING GROUP
116 West 23rd Street ▪ New York, NY 10011

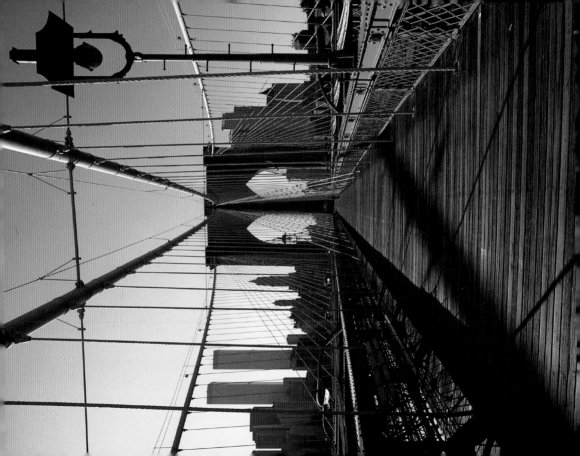

THE VIEW LOOKING WEST

From *The World Trade Center Remembered*, available from Abbeville Press

ABBEVILLE PUBLISHING GROUP
116 West 23rd Street ▪ New York, NY 10011

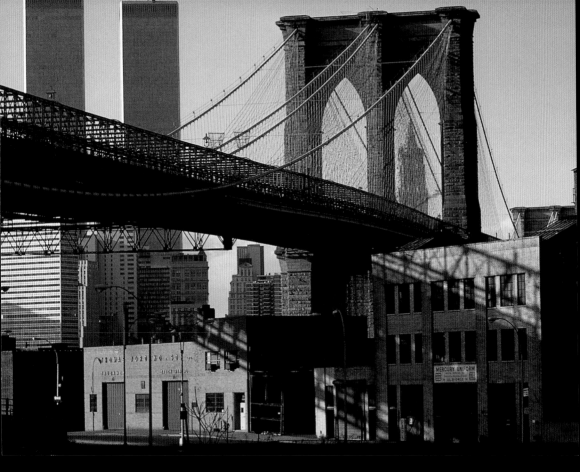

THE VIEW LOOKING WEST

From *The World Trade Center Remembered*, available from Abbeville Press

ABBEVILLE PUBLISHING GROUP
116 West 23rd Street ▪ New York, NY 10011

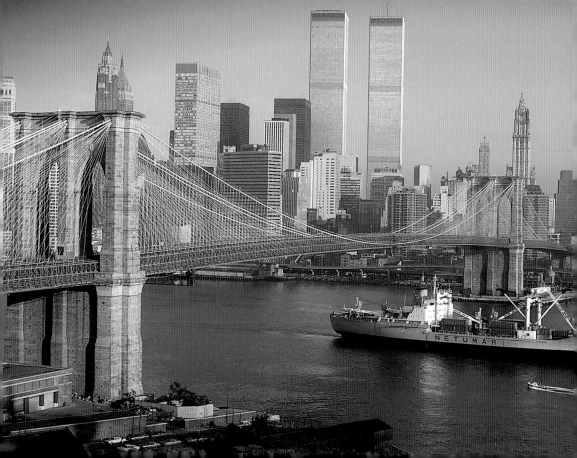

THE VIEW LOOKING WEST

From *The World Trade Center Remembered*, available from Abbeville Press

ABBEVILLE PUBLISHING GROUP
116 West 23rd Street ▪ New York, NY 10011

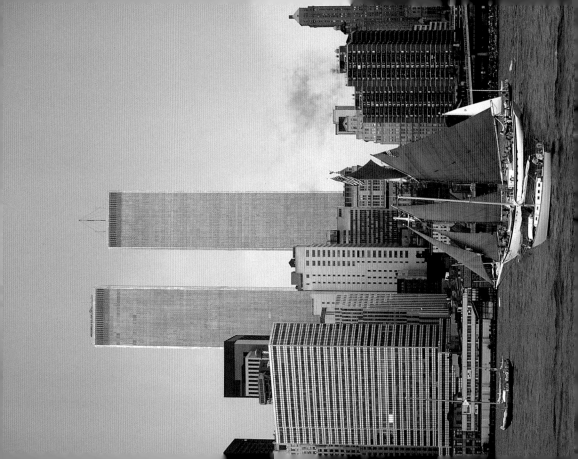

THE VIEW LOOKING WEST

From *The World Trade Center Remembered*, available from Abbeville Press

ABBEVILLE PUBLISHING GROUP
116 West 23rd Street ▪ New York, NY 10011

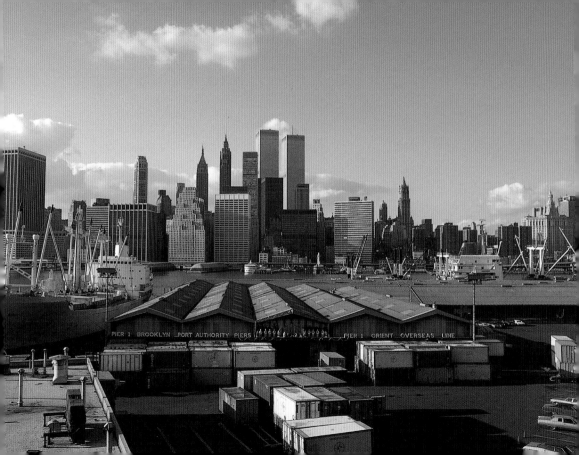

THE VIEW LOOKING WEST

From *The World Trade Center Remembered*, available from Abbeville Press

ABBEVILLE PUBLISHING GROUP
116 West 23rd Street ▪ New York, NY 10011

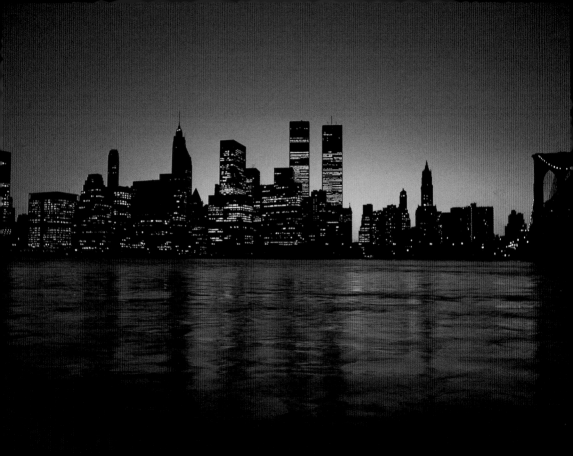

THE VIEW LOOKING WEST

From *The World Trade Center Remembered*, available from Abbeville Press

ABBEVILLE PUBLISHING GROUP
116 West 23rd Street ▪ New York, NY 10011

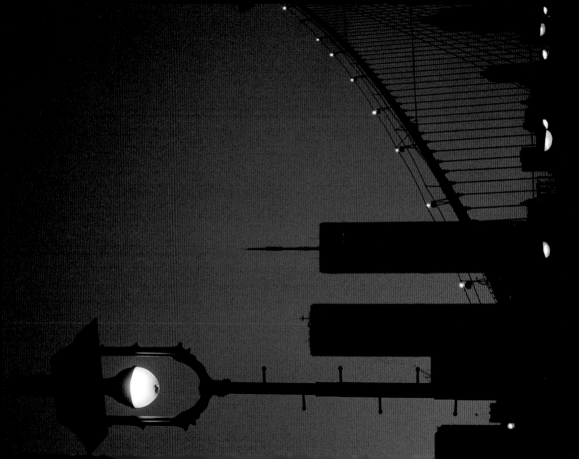

THE VIEW LOOKING WEST

From *The World Trade Center Remembered*, available from Abbeville Press

ABBEVILLE PUBLISHING GROUP
116 West 23rd Street ▪ New York, NY 10011